Creative
Hardanger

MILNER CRAFT SERIES

Creative Hardanger

GINA MARION

SALLY MILNER PUBLISHING

First published in 1994 by
Sally Milner Publishing Pty Ltd
at 'The Pines'
RMB 54 Burra Road
Burra Creek NSW 2620

Reprinted 1995, 1996, 1997

© Gina Marion 1994

Photography by Andrew Elton
Styling by Louise Owens
Design by Wing Ping Tong
Typeset by Asset Typesetting Pty Ltd, Sydney
Printed in Hong Kong

National Library of Australia
Cataloguing-in-Publication data:

Marion, Gina
 Creative hardanger

 ISBN 1 86351 136 9.

 1.Hardanger needlework – Patterns. I. Title.
 (Series : Milner craft series).

746.44

DEDICATION

I would like to dedicate this book to my late son,
Stewart.

CONTENTS

ACKNOWLEDGEMENTS

In preparing this book, I have been fortunate in the support I have received from some special people. I would particularly like to thank Jenny Bradford, whose active encouragement got this book started. Thanks are also due to Don Bradford for drawing all the diagrams.

My thanks to Elizabeth White of Down Under Designs, who supplied me with the Watercolour and Wildflower threads used in the book; to Jennifer Newman, who dyes the Minnamurra threads and who started me thinking about the use of colour with hardanger embroidery; to Ireland Needlecraft, who supplied me with the beautiful tray and were helpful in making my selection; to DD Creative Crafts for supplying the paperweights used and to Effie Mitrofanis of DMC threads, who gave me the Belfast linen for the christening gown and all the DMC threads that have been used for the projects.

A special thanks to Bev Butler who made the beautiful coathanger for the christening gown.

My thanks also go to publisher Sally Milner, for believing I had something to write about; to my family and friends for their help and encouragement and to my husband for his patience and support while I embroidered and wrote.

INTRODUCTION

Hardanger embroidery, as we know it today, comes from the south-western fjord region of Norway. Its origins are unclear, but it is known that hardanger reached Norway from Italy during the seventeenth century.

Norwegian women used to grow their own flax, then spin and weave it into the double-weave linen that was traditionally used. Thread from the same flax was also used for the embroidery. Bed linen, household linen and national custumes were embroidered.

Traditional hardanger embroidery is worked on white linen or cotton that has between 22 and 55 threads to the inch. White linen thread is used for the embroidery. The embroidery itself is based on the 'kloster block', which is five satin stitches worked over four threads. These are usually sewn at an angle, with the corners of each kloster block connecting to the next kloster block. The satin-stitch edge of each kloster block is where the threads are cut and withdrawn for the needleweaving. Other stitches are used to enhance the embroidery, such as lazy daisy, double cable and variations on needleweaving. Buttonhole stitch is used around the edge, but sometimes a combination of needleweaving and buttonhole stitch is used for a delicate, lacy edge.

Hardanger is very precise and takes time and effort to accomplish well, but is very rewarding to do. Do not be in too much of a hurry when first learning. Large projects may take some weeks from beginning to end. You should always enjoy creating with a needle and thread.

In this book, I have used coloured threads and fabric for the projects, with the exception of the christening gown. I did this partly to make the photography easier, but also because I like colour. There are so many fabrics and threads available on the market today that I would encourage you to experiment with them to suit your taste, as I have. Colour can change the whole appearance of a piece of embroidery. Do not be scared to try something different from the written instructions and in doing so, make the item uniquely your own creation.

GETTING STARTED

Read all the instructions before beginning a project, so that you have an overview of the project and a good idea of the material requirements, techniques and the sequence for stitching.

Buy the best quality fabric and threads that you can afford. So much effort is put into an embroidery that it is a shame to use poor quality materials. The difference will always show in the end result.

Before starting any project, there are two steps that need to be undertaken.

1. Cut the fabric to the required size and then overlock or zigzag stitch around all the edges to prevent fraying.
2. Using a contrasting thread, mark the horizontal and vertical centre lines with basting or tacking stitches. This step is very important, as it gives you a bearing for your work as you stitch.

The stitches also must be done in a strict order.

1. All the satin stitches.
2. All the eyelets.
3. All the outside blanket stitching.

Only after these stitches are completed should cutting take place. Otherwise, the fabric threads will pull out as you sew, particularly the eyelet stitching.

EQUIPMENT

SCISSORS

A sharp pair of fine-bladed scissors with good points for getting under the threads is absolutely essential. Slant 'n' Snip scissors are also excellent for fine cutting; these look most peculiar, but are easy on the hands when being used.

NEEDLES

A tapestry needle is used for the hardanger embroidery. This is because it has a blunt point and therefore will actually go down and come up between the fabric threads and not through them as a needle with a sharp point, as used for most other embroidery, will. When using coton perle no. 5, a no. 24 tapestry needle is used. For the needleweaving, a no. 26 tapestry needle is used. If you are unable to see the hole in the needle to thread it, use a larger tapestry needle, selecting a size that is comfortable in your hands.

The bullion stitching is done with a no. 6 straw or milliner's needle. Straw needles make bullion stitching much easier to accomplish and are less frustrating to use than crewel embroidery needles. A straw needle is designed so it has a uniform thickness

and only tapers at the tip, which makes pulling the needle through the wrapped threads much easier. A crewel embroidery needle is used for the other embroidery stitches.

When using any needle, once the shiny layer on the outside of the needle has worn off, throw the needle away. This layer allows the needle to slide through the fabric easily and when the layer is gone, it is hard to push the needle through.

HOOPS

A hoop should be used for hardanger embroidery to help keep an even tension throughout the work and to prevent the stitching from being pulled too tight and puckering the work. It should also be used for the satin and buttonhole stitching. You will find that either a wooden or spring-loaded hoop is satisfactory to use.

MATERIALS

THREADS

Throughout this book, I have used coton perle and DMC stranded threads. I have also used a small amount of flower thread for the tray cloth.

Traditionally, only coton perle was used, but a variety of suitable threads are now available. Depending on the piece of work and your personal preference, the choice of threads is yours. Coton perle has a lustre that contrasts nicely with the matt finish of the fabric. DMC stranded threads also have a lustre, but give a different finish to the embroidery. The coton perle will sit up from the fabric, while the stranded thread will sit flat against it.

When working on the Lugana fabric, coton perle no. 5 and no. 8 are used. When working on the Belfast fabric, coton perle no. 8 and no. 12 are used. The higher the number of the thread, the finer it is: no. 5 is fairly thick, while no. 12 is fine. The finer the fabric the finer the thread that has to be used. The rule for stitching is that the thicker thread is used for all the satin and buttonhole stitching, but stranded thread can also be used for these stitches.

Perle thread often unravels as you embroider. Check the thread often and if it is untwisting, take the time to twist it back again or it will detract from the finished article.

Watercolour thread is equivalent to coton perle no. 5, but it has been hand painted to give a lovely range of colours on each thread. Wildflower thread is equivalent to the coton perle no. 8 and matches the Watercolour threads in colour. These threads do not have a high lustre like the coton perle, but look lovely on the finished article.

Minnamurra threads are hand-dyed, DMC, six-stranded threads. There are usually two colours on each strand and there is a range of 20 colour combinations. I have used Minnamurra threads for both the hardanger embroidery and the basic embroidery, such as the bullion stitches.

When using variegated threads, make sure that one section of the embroidery is done at a time, especially when needleweaving, or the result can look quite messy. If variegated threads do not appeal to you, I have given alternative colours for the threads in plain DMC stranded threads.

I have listed wholesale suppliers of the threads at the back of the book. Do not hesitate to contact Down Under Designs for the Watercolour and Wildflower threads and Jennifer Newman for the Minnamurra threads.

DMC flower thread is a fine thread for embroidery, use it when a matt finish and a delicate touch is required. It contrasts nicely with the coton perle and complements the hardanger embroidery.

The final thread that I have used is a gold metallic thread. It is DMC Fil or clair light gold thread. It has been used only on the christening gown for the eyelets on the crosses.

All the threads for any project should be bought at one time. This is especially important when using the variegated threads. The colour varies with each dye lot and it can be very hard to find the same dye lot again.

The length of the thread used is most important. As with all threads, the longer the thread, the more times it has been pulled through the fabric. Each time it is pulled through the fabric, the thread wears and loses its lustre and twist. Make sure that the thread is no longer than 38 cm (15 in) or it becomes very obvious where you end and start a new thread and this detracts from the work. When working with the gold metallic thread, a very short length — 25 cm (10 in) — should be used as it is particularly prone to fraying.

FABRIC

Traditionally, hardanger embroidery was done on a white double-weave linen. For all my work, I have used Lugana and Belfast linen. Lugana is a firm fabric and has a percentage of polyester in it. The Belfast is a pure linen and is finer to work on than the Lugana. Lugana is a 26-count cloth and Belfast is a 32-count cloth. The higher the count, the finer the fabric. Thus, the Belfast linen gives a finer finish to the article. I have used it for the tray cloth and the christening gown. Lugana comes in nine different colours, so there is a choice of colours open to you. Belfast comes only in cream and white. Cotton Oslo can also be used, but I find it is not firm enough to hold the embroidery effectively.

THE DESIGNS

The designs for hardanger embroidery are always depicted on graphs. For the smaller articles, such as the paperweights, I have shown the whole graph. For the larger articles, either half or one quarter of the graph is shown. In this case, the graph will need to be turned and repeated to complete the whole pattern. The designs are sometimes graphed in two colours, in black and grey lines. Wherever the design line is black, the coton perle thread has been used. Wherever the design line is grey, Minnamurra threads are to be used. Always read the instructions thoroughly before beginning a project and, if in doubt, consult the photograph.

Hardanger is a very precise type of embroidery. The counting and embroidery must be exact if the article is to have a pleasing appearance when finished. On the graphs, each graph line represents a fabric thread. Because the satin stitches are done between the fabric threads, they are represented on the graph between the graph lines. They are also depicted as the heavier line over the graph lines.

CARE OF HARDANGER EMBROIDERY

As with all embroidery, care should be taken with the article from the beginning to the end.

Before starting, wash your hands with soap and water and dry them thoroughly to keep the work as clean as possible while working on it. If it needs laundering, only wash when the whole article is finished, unless a substance that will stain has been spilt on it.

To wash the embroidery, use lukewarm water and a gentle detergent or soap. Do not wring the embroidery. Press as much water as possible out of the fabric by hand, then place it on a clean towel and roll it up. Squeeze the towel gently, unroll it, and place the embroidery on a rack out of the sun to dry. When the embroidery has dried, place it face down on a dry towel on an ironing board. Place a piece of cloth, such as a man's handkerchief, over the embroidery (this will prevent scorching if the iron is too hot). Iron carefully with a hot iron. Ironing directly on top of the embroidery will flatten the work and detract from the finished article.

With the Watercolour and Wildflower threads, extra care must be taken with cleaning. Because of stringent environmental laws, the chemical fixatives that were used to stop the dyes from running can no longer be used. Therefore, all embroidery with these hand-dyed threads should be washed in cold water with a little salt or vinegar added.

When washing any type of embroidery, never rub or wring the article as the embroidery threads become fluffy and the finished article can be ruined.

TECHNIQUES

KLOSTER BLOCKS

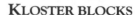

Kloster blocks are the basis of hardanger embroidery. Each block is always five satin stitches over four threads. This never varies.

This stitch is worked with the thicker of the two coton perle threads that are used: coton perle no. 5 on the Lugana and coton perle no. 8 on the Belfast linen.

Kloster blocks are embroidered in two different ways:
1. on the diagonal.
2. in a straight line.

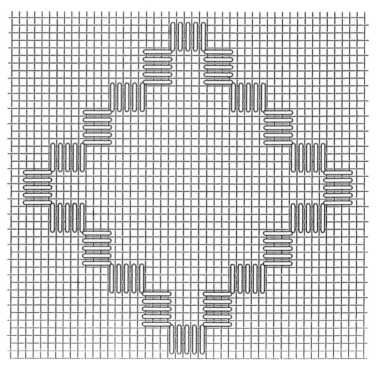

Kloster blocks on the diagonal

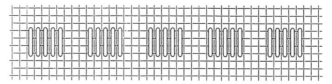

Kloster blocks in a straight line

Kloster blocks may be worked from left to right or right to left. Each block consists of five satin stitches, always worked from the bottom to the top of the block. This gives each block an even look.

BLOCKS ON THE DIAGONAL
Kloster blocks are usually worked on the diagonal of the fabric to outline the design being used.

- Starting at 1, work five satin stitches, following the numbered stitch order in the diagram.
- To make the second block, count four fabric threads to the left of the 10. Push the needle through at 11, take the needle back to 10 and pull the needle through. Complete in the same way as the first block.
- To make the third block, after completing stitch 19 to 20, take the needle back through 19 and come up to the front. Count four threads up from 19 and take the needle through to the back at 22 and come up at 23.

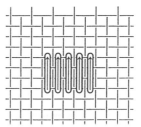

Arrows indicate the direction of the stitch

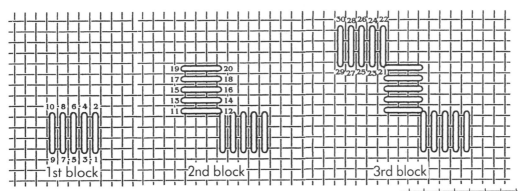

The hole in each corner is shared with the next block. If the back looks like the diagram shown, the stitching has been done incorrectly. There should be no jumping diagonally from one block to the next.

The back should look like this.

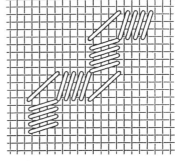

Back of work — wrong

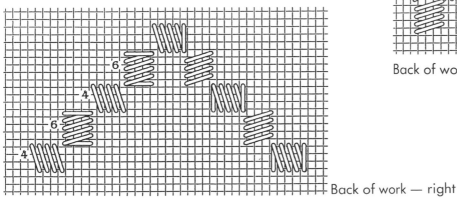

Back of work — right

The stitching on the back should be on an angle and alternate blocks of 4 and 6 stitches on the diagonal.

BLOCKS IN A STRAIGHT LINE

The first block is embroidered in the same way as the first block embroidered on the diagonal.

When that is completed, count over four threads from the bottom right corner of the first block. This is the starting point of the second block.

This process is repeated to make a straight line of kloster blocks. The back of the embroidery should look like the top diagram, not the lower one. If the stitching has been done the wrong way, the blocks will not sit correctly.

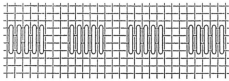

Front of work

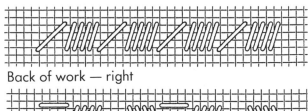

Back of work — right

Back of work — wrong

It is critical that the blocks are correctly embroidered because the satin-stitch edge is where the fabric is cut. If the stitching is done incorrectly, then there is nothing to hold the fabric threads in place when they are cut.

STARTING AND FINISHING A THREAD

When starting a thread, tie a knot in the end. Take the needle through the fabric from the top to the bottom approximately 8 cm (3 in) from the starting point. Start and complete the kloster blocks with the thread.

To end the thread, run it back and forth three times under the last kloster block, catching the fabric with the needle. Now go back to the beginning of the thread. Cut off the knot, thread the needle with the cut end and finish in the same way as for the end of the thread. This process is known as 'a waste knot'.

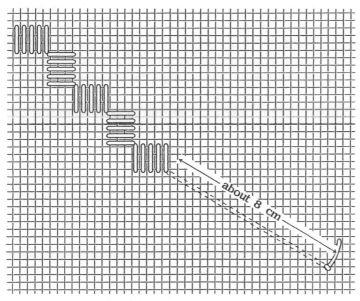

Starting a thread waste knot

EYELETS

Eyelets are decorative stitches that can be used by themselves, between two rows of kloster blocks or between a row of kloster blocks and a row of buttonhole stitches. If the eyelets are used in conjunction with buttonhole stitching, then the eyelets must be embroidered before cutting around the buttonhole edging or the fabric threads will pull out.

Eyelets are worked in the finer coton perle thread, usually the coton perle no. 8 or no. 12.

There must be 4 x 4 threads in the centre of two rows of kloster blocks to be able to embroider an eyelet.

- Coming up at A take the needle through the centre and bring it up at B. Pull the stitch tight.
- Go down through the centre again and come up at C. Pull the stitch tight.
- Repeat this process until stitches have been sewn into all the satin stitches of each kloster block.

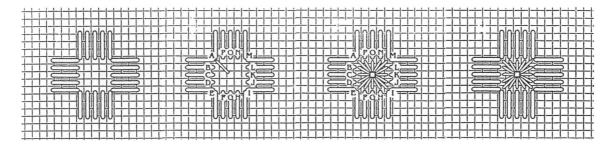

The tighter the thread is pulled after each stitch, the larger the hole becomes in the centre. It is much easier to make a hole by going down through the centre instead of coming up through the centre. If one stitch lies on top of the previous stitch, pull the thread tighter so that it lies flat against the fabric.

When moving from one eyelet to the next, run the thread under the kloster blocks on the back. Make sure the starting point is always in the same place on each kloster block.

Anchor the ends of each thread by running back and forth three times under the closest kloster block, catching the fabric threads.

ALGERIAN EYELETS

Algerian eyelets are used for the same reason as eyelets, and they can also be used for decorative purposes. They are done with either a coton perle no. 8 or no. 12. If they are done in conjunction with a buttonhole edge, they must be embroidered before cutting.

- Starting at A (the first stitch of a kloster block), bring the needle up from underneath the fabric.
- Find the centre and take the needle down through it and come back up at B (the centre stitch of the group of five for a kloster block).
- Go down through the centre again and come up at C (the last stitch of the kloster block).
- Repeat the process until the eyelet is completed.

Start each Algerian eyelet at the same corner with each block. Run the thread underneath the kloster blocks to reach the next block.

SATIN STITCH

Satin stitch is one of the most difficult stitches to do really well. It is made easier on an even-weave linen, because the fabric threads space each stitch evenly. The tension also has to be practised so that the stitches are not pulled too tightly, which causes puckering of the fabric underneath.

- To start, use a waste knot going through the fabric from the top approximately 8 cm (3 in) from the starting point A.

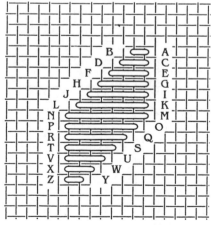

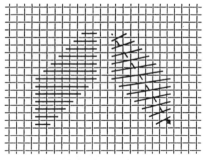

Front of work Back of work

- Come up at A and take the needle down at B, up at C and down at D. Continue the process until the block is finished. The back should be a satin-stitched

block with slanted stitches. The back should never have little stitches from B to D, C to E, and so on. Incorrect stitching will make the satin stitches sit on an angle instead of sitting straight across the fabric. Always finish the whole block before finishing off the thread.

- When the thread is finished, take it through to the back and run it under the last finished block. Cut the waste knot at the beginning of the thread, thread the needle with the end and run it under the first block.

CABLE AND DOUBLE CABLE STITCH

This stitch has been used extensively for the projects in this book, both as a single and a double row. It gives a lovely raised effect either way and looks good with any sort of embroidery.

A coton perle no. 8 or no. 12 is used to embroider this stitch. The stitch is done over two threads only. It is worked from left to right on the diagonal.

- For the first row of cable stitch, start with a waste knot and come up at 1.
- Count two fabric threads to the right and two fabric threads up from 1. This is 2. Take the needle down at 2 and come up two fabric threads to the left, but along the same horizontal thread, this is 3.
- Now count two fabric threads up from 2, this is 4. Take the needle at 4, back up at 5, through the same hole as for 2.
- Continue in this method until the required number of stitches has been embroidered.

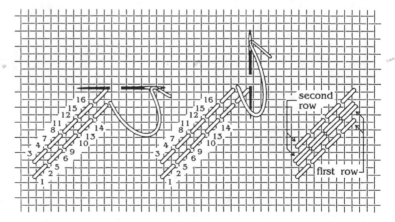

- The second row of cable stitch that makes it double cable stitch, is done in the same way as the first, but shares the middle line of holes with the first row.

The same method is used, but be careful that the new middle row does not sit on top of the first row. Corners are embroidered exactly the same way for both rows.

TURNING A CORNER

To turn the corner, an extra stitch has to be made to compensate for the turn.

- Work to the corner, taking the needle down through the fabric at 14.
- The turning stitch cannot finish and start with the same stitch, but you need to work from the same hole. Take the needle and come up at 15 (two threads up and two threads to the left of 14).
- Take it to the back at 16 (the same hole as for 14), then up at 17 (the same hole as for 12), and the new row is ready to begin.
- Work the stitches in the new direction as before, taking the needle down at 18 and back up at 19 (the same hole as for 15).

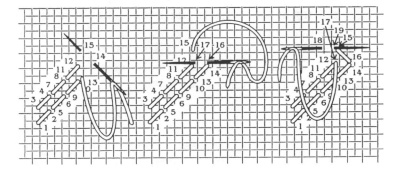

CUTTING AND WITHDRAWING THREADS

Good light and a pair of sharp, fine-pointed scissors are essential for cutting out. Never start cutting threads when you are tired. Cutting errors are hard to fix and very time-consuming, so it is better if they can be avoided.

All kloster blocks must be completed before cutting can begin. Each kloster block must have an opposite kloster block so all the cut ends are secured.

Each kloster block has a stitched edge and an unstitched edge. It is only along the satin-stitched edge that cutting takes place. Although there are five satin stitches, only the four fabric threads within the kloster block are actually cut.

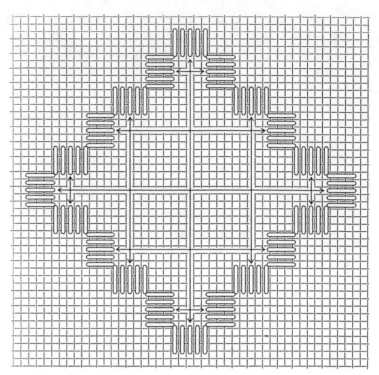

Arrows indicate
where you cut

All cutting is done from the back. The scissors are placed under the four threads with the scissor blade to the left of each kloster block. This makes the scissor blade as close as possible to the kloster block when cutting, eliminating fluffy cut threads.

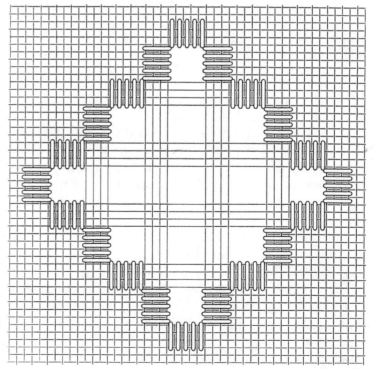

Grid of threads with
cut threads withdrawn
ready for
needleweaving

Place the blade under each thread, pull it up slightly and then cut the thread. **Only cut four threads on each block.** When the threads have been cut, carefully withdraw them (pull them out). A grid of threads as shown in the diagram should be left. These threads are now ready for needleweaving.

FIXING CUTTING MISTAKES
Mistakes can happen when cutting. If you cut incorrectly, do not panic. Mistakes can be fixed but it takes time and lots of patience. Here are some common problems, and how you can deal with them.

Five threads have been cut instead of only four threads at one end of a kloster block

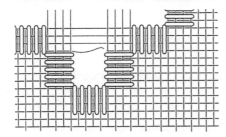

Withdraw the surrounding threads as usual. There will be a bar with four threads at one end and three threads plus the cut thread at the other end. Starting at the end with the four threads, needleweave as usual, making sure that the loose thread is caught securely at the other end. This woven bar may not be quite as wide as other woven bars.

The unsewn edge of the kloster block is cut
Withdraw the cut threads back to the edge of the embroidery. Carefully withdraw the same number of threads from the edge of the fabric. Weave these threads back into the fabric where the cut threads were withdrawn. Repeat this process ending each thread inside the kloster block, until each of the withdrawn threads have been replaced.

The kloster block thread or buttonhole edging thread is cut while cutting the fabric threads
Very carefully undo several kloster blocks on both sides of the cut block until there is enough thread to secure an end. Secure the threads at both ends. With a new thread, restitch the kloster blocks making sure the thread is not pulled too tight. Secure both ends of the new thread.

For the buttonhole edging, undo enough of the thread in both directions to secure the ends. With a new thread, restitch the buttonhole edging.

WOVEN BARS (NEEDLEWEAVING)

When the threads have been cut and withdrawn, a grid of threads is left. These threads are then needlewoven. Needleweaving strengthens the cut threads and also adds decorative stitching to the finished embroidery. Needleweaving can be left plain, or, other stitches such as picots, dove's eyes or square filets can be added. Each of these stitches is ornamental and adds to the lacy effect of the finished embroidery.

Woven bars are done with a coton perle no. 8 and no. 12.

- Starting with a waste knot, come up at 1.
- There should be four weft threads. Place the needle over the first two threads then take the needle under the third and fourth threads. Now reverse the process. Take the needle over the third and fourth threads and then under the first two threads. A figure 8 has been made under and over the weft threads. Repeat this process until the bar has been filled: there will usually be seven stitches on both sides of each bar. Like the kloster blocks, the needleweaving is done in steps until all the bars are completed.

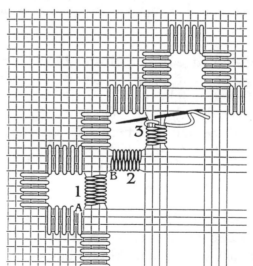

- To move from one bar to the next, the thread should be brought up from under the first bar to where the bars intersect (2). Take the needle and go over the first two threads of the next bar, then under the third

and fourth threads. Continue the needleweaving until the bar is completed.

- When finishing the thread, take it to the back of the embroidery and run the thread through the stitching on one side of the woven bar and then through the second side of the bar. Going back to the beginning of the thread, cut the waste knot and finish the thread using the same method as above.

When using variegated thread, it is better to weave a square at a time instead of stepping the embroidery up the bars. Variegated thread can look quite messy if rows are embroidered.

PICOTS

Picots are combined with the needleweaving to add a lace effect to the embroidery. They are done with a coton perle no. 8 or no. 12.

Picots can be embroidered on both sides of each woven bar, as I have done with the christening gown, or worked on one side of the bar in combination with another stitch.

PICOT TO THE RIGHT
- Needleweave half of the bar, finishing with the thread to the right of the bar.
- Take the needle and place it under the two threads on the right side of the bar with the needle pointing to the right again.
- Take the needle and place it under the two left threads with the needle pointing to the left.
- Take the thread under the needle and wrap it around once (like a French knot). Place your thumb over the thread to hold it in place.
- Pull the needle through carefully, leaving a small loop. Do not pull the loop tight or you will lose the picot. Continue needle weaving to complete the bar.

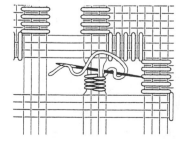
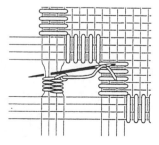

PICOT TO THE LEFT
- Weave half the bar, finishing on the left side of the bar.
- Take the thread under the needle and wrap it around the needle once. Place your thumb over the thread and needle to hold it in place.
- Pull the needle through in the same way as a picot to the right. Continue needleweaving to complete the bar.

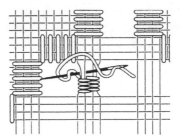 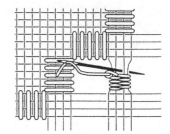

DOVE'S EYES

Dove's eyes are another decorative stitch used in combination with woven bars. They are stitched at the same time as the needleweaving is being done. They are worked in coton perle no. 8 or no. 12. All the loops should cross over in the same direction.

- Needleweave 3 ½ sides of the square.
- Coming up from underneath the bar, finish with the needle in the centre of the square.
- Take the needle, place it through the middle of the previous bar and bring it up in the centre of the square, looping the thread under the needle.

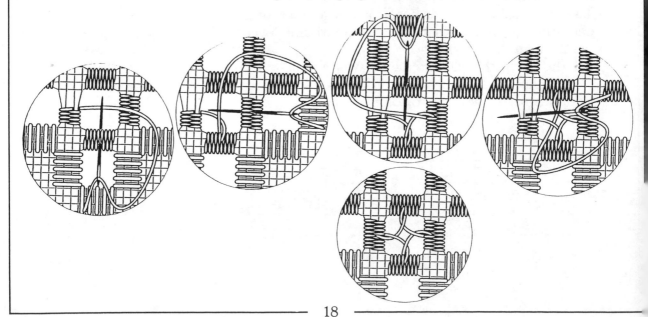

- Repeat this process until three sides have been completed.
- Take the needle and place it under the very first loop, then take it over the first two threads of the last bar and continue the needleweave until the bar is completed.

SQUARE FILETS

These stitches are similar to dove's eyes but are worked from corner to corner of the block. They are usually used in conjunction with woven bars and picots. All square filets should be worked around the square in either a clockwise or an anti-clockwise direction. They will cross differently if worked in a different direction.

- Needleweave all four sides of a square, placing picots on the outside of the bars.
- When the bars are completed, come up at A. There needs to be two fabric threads on each side of A.
- Find B (this will also have two fabric threads on each side) and come up from underneath.
- Take the needle and place it **under** the loop made by the thread from A to B. Pull the needle through.
- Take the needle and come up at C.
- Take the needle under the second loop and pull it through.
- Bring the needle up at D.
- Place the needle under the third loop and pull it through.
- Take the needle and place it over the first loop and take it through to the back. There is a small straight stitch on the back from the last woven bar to A. Slip the needle under this stitch and pull it through. The thread can now be taken to the next bar for needleweaving.

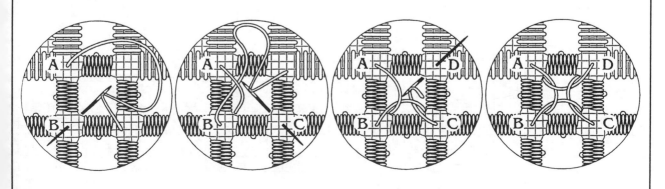

MALTESE CROSSES

This is a very decorative stitch, which has been used throughout the book. It gives a lovely lacy effect. It is done with the finer of the two threads, the coton perle no. 8 or no. 12.

- On the inside of each square block of 12 threads, cut four fabric threads from the corner, working into the centre of the square. Withdraw these cut threads. There should be four threads in the centre of the square both vertically and horizontally. These are the threads the Maltese Cross will be worked on.
- To start, run the thread back and forth twice under the satin stitching on the back and come up at 1.
- Starting at 1, wrap the two threads on the right four times if using coton perle no. 8 and five times if using coton perle no. 12.
- With the next wrap, take the thread under the first two horizontal threads on the right. Now weave back and forth over and under, between the two sets of threads, making eight stitches in all (four on each set of threads), ending at the two unwrapped threads.
- Wrap these threads four or five times, depending on the thread you are using. This completes the first quarter of the block.
- Repeat the process with the remaining bars.

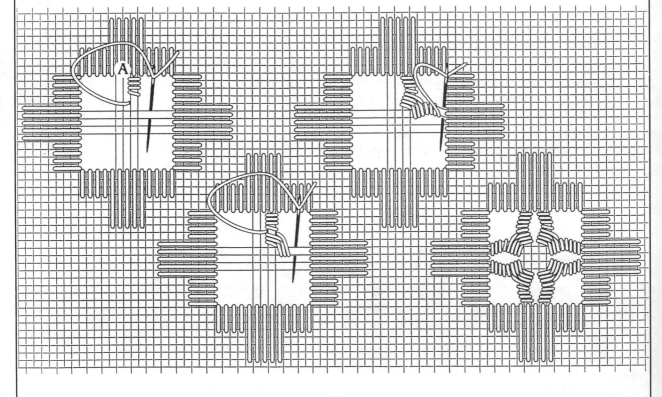

BUTTONHOLE STITCH

Buttonhole stitch is used around the edge of hardanger embroidery to give a secure edge. For each fabric thread, there is one buttonhole stitch along a straight edge. This varies when working around a corner.

The coarser thread — when working coton perle no. 5 or no. 8 — is used for buttonhole stitching. Whichever thread is used for the kloster blocks, is the same thread used for the buttonhole stitching. This stitch is worked from left to right.

There is a buttonhole stitch to correspond with every kloster block stitch, plus three corner stitches. On an inside corner, the last stitch of one group of buttonhole stitches and the first stitch on the next group share a hole with stitches of adjacent kloster blocks.

TURNING AN OUTSIDE CORNER

- Start buttonhole stitching eight threads below the corner of a kloster block. Starting with a waste knot, come up at A.
- Count four threads vertically up from A and one row to the right, place the needle in at B and back out at C, one thread to the right of A.
- Loop the thread under the needle and pull the needle through. This is the first stitch.
- Make three more stitches in exactly the same way.
- To turn the outside corner, the thread is pivoted at B, while counting two threads to the right of the last stitch and coming up at C.
- The thread is again pivoted at B and, counting two threads to the right, the needle comes up at D.
- Now turn the fabric around 90° so the buttonhole stitching that you have just completed is placed vertically over the fingers of your left hand.
- Put the needle into the fabric at B again, count two threads to the right of D and come up at E.

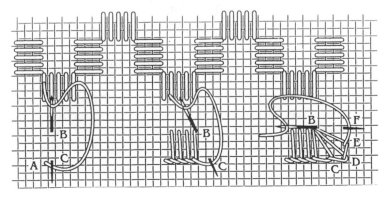

- The final stitch is made by going into the fabric at B, counting over two more threads to the right of E and coming up at F. The corner has now been turned. The last stitch made is the first of the five buttonhole stitches that run parallel with the kloster block immediately above it.

TURNING AN INSIDE CORNER
- Work an outside corner and the five buttonhole stitches to correspond with the kloster block.
- Count up four threads and slip the needle in, coming up in the same hole as the last buttonhole stitch.
- Loop the thread under the needle and pull it through.
- Make another four buttonhole stitches. This completes the inside turn.

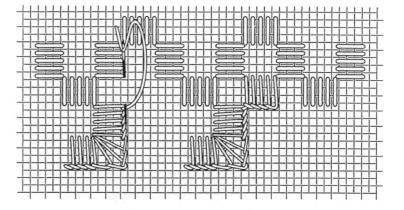

STARTING AND FINISHING A THREAD
Initially a waste knot is used on the end of the thread. After the thread has been used, the end is run under the previous stitching. Cut the waste knot off and run the end under the stitching.

CUTTING AROUND BUTTONHOLE STITCHING
All embroidery must be completed before cutting around the outside edge takes place.

Hardanger embroidery is cut out from the back. Place the blade of the scissors under the fabric threads as close to the buttonhole stitching as possible. Lift each thread and carefully cut it. Continue around the complete design. This is the most time-consuming part of the embroidery. Care must be taken so that the buttonhole stitching is not cut as well as the fabric threads.

BACK STITCH

Back stitch is a stitch used for outlining highlighting or to define a straight line. The stitch is worked from right to left.

- Using a waste knot, go through the fabric from the top 8 cm (3 in) from A. Come up at A.
- Take the needle and place into B (four threads to the right of A) and then jump to C (four threads to the left of A) and bring the needle to the front.
- Take the needle back at A and then jump to D (four threads to the left of C). The needle and thread are always ahead of the stitch to be made, and you go back to the previous stitch to complete it.

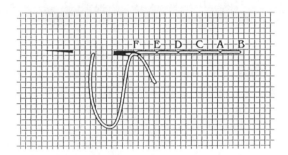

- To end the thread, run it under the stitching on the back. Cut the waste knot from the beginning of the thread and repeat the process to finish it.

BULLION STITCH

- Using a waste knot, come up at A.
- With the needle facing towards you, take a straight stitch four fabric threads away at B. Pull the needle and thread completely through.
- Take the needle back to A and come up at B again, but do not pull the needle through.
- Take the thread and wrap it around the needle nine times.
- Using your thumbnail, push the wraps down the needle towards the fabric. Place your thumb on the wraps and pull the needle through. Pull the needle away from you so that the thread is tight. This should make the wraps sit against the fabric.
- Take the needle down through A again. The stitch is now complete.
- The ends of the thread are run through the stitching on the back to finish off.

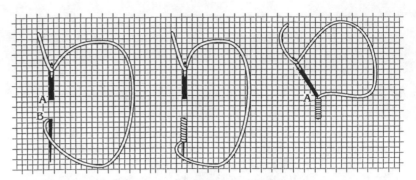

COLONIAL KNOTS

This knot is used as the centre of the daisies, whether they are worked in bullion or lazy daisy stitch.

- To start the thread, run it under the stitches surrounding the point where the colonial knot is to be placed.
- Place the fabric on a hard surface. With your left hand, hold the thread approximately 5 cm (2 in) from A, with your thumb and first finger.
- Take the needle in your right hand and move the needle under the thread from the left side. Take the thread in your left hand and place it over the top of the needle, then under the right side of the needle.
- Place the needle back in the fabric one thread to the right of A.
- Before taking the needle through to the back, pull the knot tight and then pull it through. The knot is now completed. If the knot is not pulled up tight, the stitch will be large and loopy. The thread makes a figure of eight around the needle.
- Finish the thread by running it under the stitching surrounding the colonial knot.

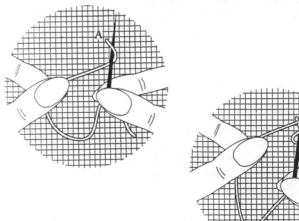

- Finish the thread by running it under the stitching surrounding the colonial knot.

LAZY DAISY STITCH

This stitch has been used on the tray cloth. The lazy daisy stitches have been made to form each petal and leaf; then a straight stitch has been placed inside each lazy daisy stitch.

- Coming up at A, take the needle back into A and come up at B (four fabric threads from A).
- Before pulling the needle through, take the thread and loop it under the needle. Pull the needle through carefully, leaving enough thread to make a fat petal or leaf.

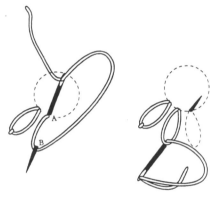

- Take the needle and push it through to the back close to B, on the outside of the loop. This secures the loop and allows you to start the next daisy stitch.
- The straight stitch inside the loop is made from A to B.

HOLBEIN STITCH

This stitch has been used on the blue doily. It looks like back stitch on the end of the white diamonds, but it is actually Holbein stitch. It is a running stitch worked over two threads each time. The first row partially outlines the shape and the stitching is then reversed and the spaces filled in.

- Following the diagram, make stitches 1, 2, 3 and 4.
- Now reverse the direction and complete the line by embroidering stitches 5, 6, 7 and 8. When embroidering the second line of stitches, come out of the right of 4 and go down to the left of 3. Repeat this process so a continuous line is formed.

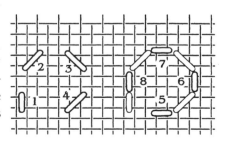

MAKING A TASSEL

- Cut 2 m (1½ yd) of coton perle no. 5.
- Cut a piece of medium-weight cardboard 5 cm (2 in) square.
- Wrap the thread around the cardboard.
- Thread a 20-cm (8-in) length of coton perle no. 5 on a needle. Slip the needle under one end of the wrapped thread and tie it in a knot.
- Remove the cardboard from the thread. Take another piece of thread 20 cm (8 in) long, and wrap it around the tassel head 1 cm (½ in) from the tied thread. Finish the end of the thread by running it under some of the wraps.
- Cut the looped ends and trim them to look neat, if necessary. Use the tied piece of thread to attach the tassel.

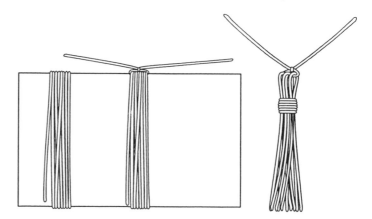

PROJECTS

You now have all the information that you need to start embroidering and are now ready to start a project. You will find that I have started with the easier projects first and then gradually worked up to the larger, more complex projects. I suggest that you start with one of the small items before trying the harder, larger items.

SAMPLERS

FIRST SAMPLER
Finished size: 26 cm (10¼ in) square

REQUIREMENTS
33 cm (13 in) square of light blue Lugana
2 balls DMC coton perle no. 5 in white
Tapestry needle no. 24
1 ball DMC coton perle no. 8 white

METHOD
Since this piece of fabric is square, the following measuring instructions can be made from any corner. Measure 19 cm (7½ in) along one side and 4 cm (1½ in) up from the bottom left corner. This is the starting point for your embroidery. Embroider the stitches in the following order:

- All the kloster blocks with coton perle no. 5.
- Double cable stitch with coton perle no. 8.
- All the satin-stitch patterns (the diamonds, star and square inside each diamond) with coton perle no. 5.
- Algerian eyelets with coton perle no. 8.
- Buttonhole stitch with coton perle no. 5.

After this has all been completed, cut out the work from the back. Place the scissor blade under the fabric threads next to the buttonhole stitching. Lifting each fabric thread, carefully cut out around the design. Press with a hot iron on the wrong side. You have now completed your first sampler.

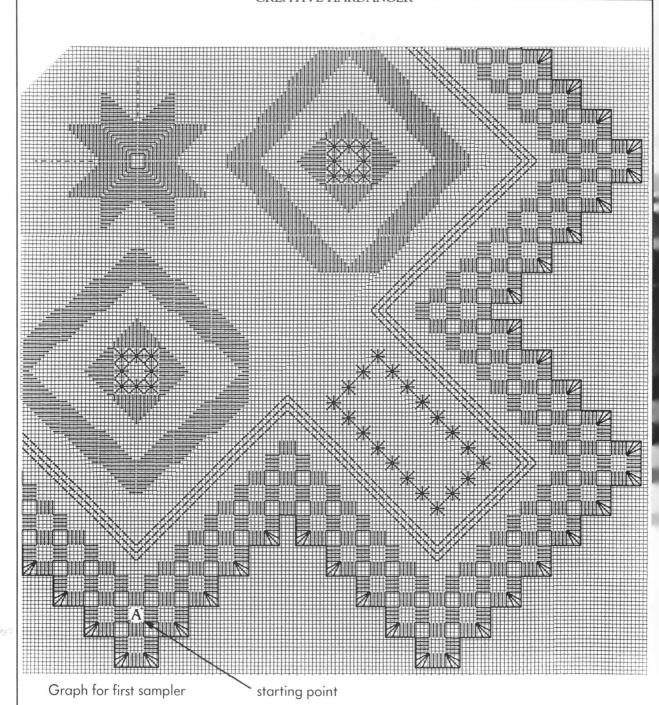

Graph for first sampler starting point

SECOND SAMPLER
Finished size: 23 cm (9 in) square

REQUIREMENTS
32 cm (14½ in) square of beige Lugana
2 balls DMC coton perle no. 5 in colour 644

1 ball DMC coton perle no. 8 in colour 644
Tapestry needles no. 24 and no. 26

METHOD
This piece of fabric is a square. Measuring may take place along any side. Measure 18 cm (7 in) along one side and 2 cm (¾ in) up. This is the starting point of the embroidery. Embroider the stitches in the following order:

- Kloster blocks with coton perle no. 5.
- Double cable stitches with coton perle no. 8.
- Satin stitch with coton perle no. 5.
- Algerian eyelets with coton perle no. 8.
- Large eyelets with coton perle no. 8.
- Buttonhole stitch with coton perle no. 5.

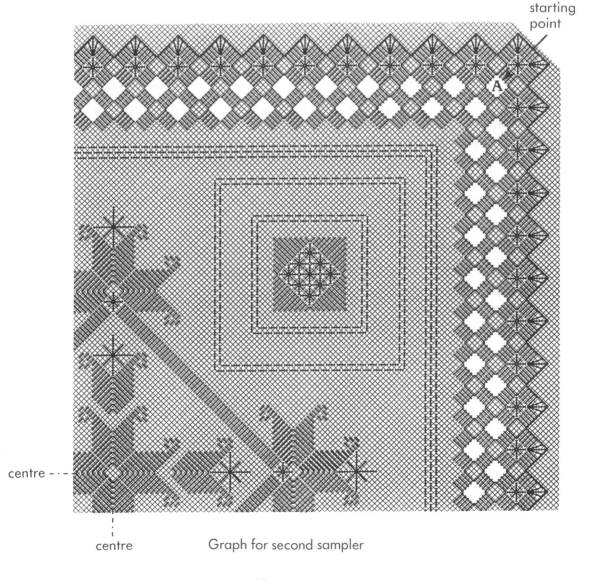

starting point

A

centre

centre

Graph for second sampler

- Eyelets between the kloster blocks and the button-hole stitching with coton perle no. 8.
- Once all these stitches have been completed, the cutting can commence. Cut the fabric and needle-weave one section at a time, so the task does not seem so enormous.

Finally, cut around the outside edge from the back. Place the scissor blade under the fabric threads next to the buttonhole stitching. Lift each fabric thread and carefully cut around the design. Press carefully on the wrong side.

BOOKMARKS

HEART BOOKMARK
Finished size: 3 cm x 12 cm (1¼ in x 4¾ in)

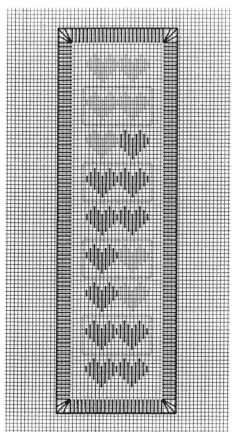

Graph for
heart bookmark

REQUIREMENTS
18 cm x 7 cm (7 in x 3 in) of blue Lugana
1 skein Minnamurra thread in colour 20 *or* DMC
stranded thread in colour 211
1 skein DMC coton perle no. 5 in white
Tapestry needle no. 24

METHOD
Find the centre of the fabric and use this as the starting
point. Embroider the stitches in the following order:

- Satin stitch hearts using three strands of Minnamurra
 thread.
- Back stitch around the hearts using three strands of
 Minnamurra thread.
- Buttonhole stitch with coton perle no. 5.

Cut around the outside edge from the back and then
press with an iron on the wrong side. Make a tassel
(see page 26) and attach it to the centre of the bottom
of the bookmarks.

WHITE AND GREEN BOOKMARK
Finished size: 5 cm x 14 cm (2 in x 5½ in)

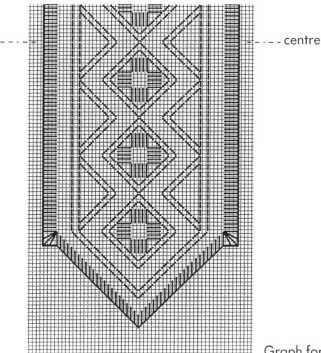

centre

Graph for white and green bookmark

REQUIREMENTS
18 cm x 9 cm (7 in x 3½ in) of white Lugana
1 skein DMC coton perle no. 5 in colour 504
Tapestry needle no. 24
1 ball coton perle no. 8 in colour 504

METHOD
Find the centre of the fabric and use this as the starting point. Embroider the stitches in the following order:

- Double cable stitch with coton perle no. 8.
- Back stitch with coton perle no. 8.
- Kloster blocks with coton perle no. 5.
- Buttohole stitch with coton perle no. 5.

Cut out around the edge from the back and then press with an iron on the wrong side. Make a tassel (see page 26) and attach it to the centre point of the buttonhole stitching at the bottom of the bookmark.

DIAMOND BOOKMARK
Finished size: 4 cm x 13 cm (1½ in x 5 in)

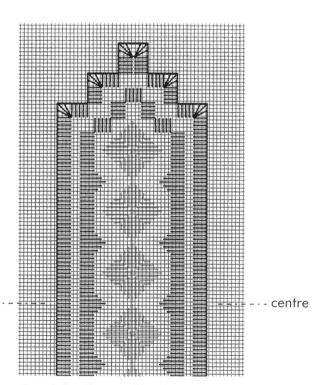

- - - centre

Graph for diamond bookmark

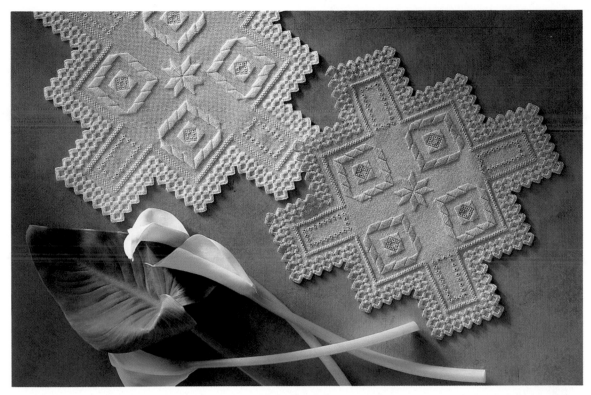

FIRST SAMPLER

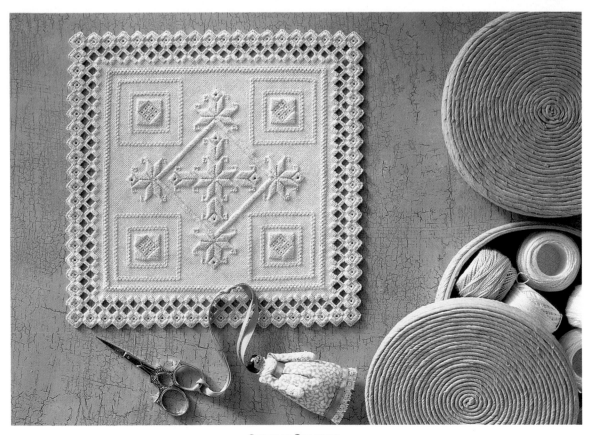

SECOND SAMPLER

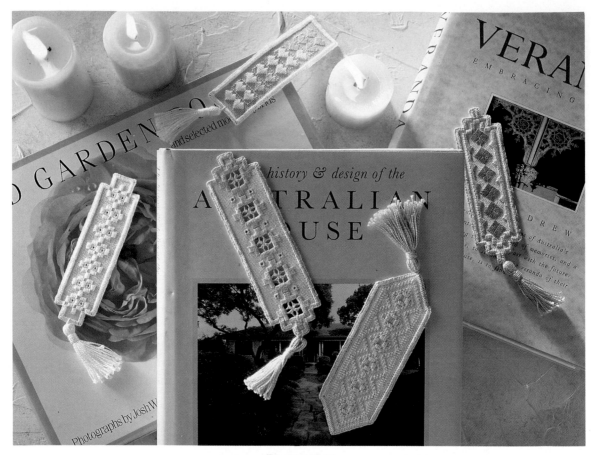

BOOKMARKS

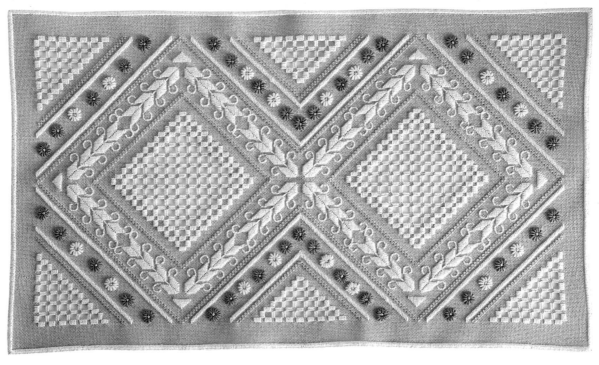

BLUE DOILY

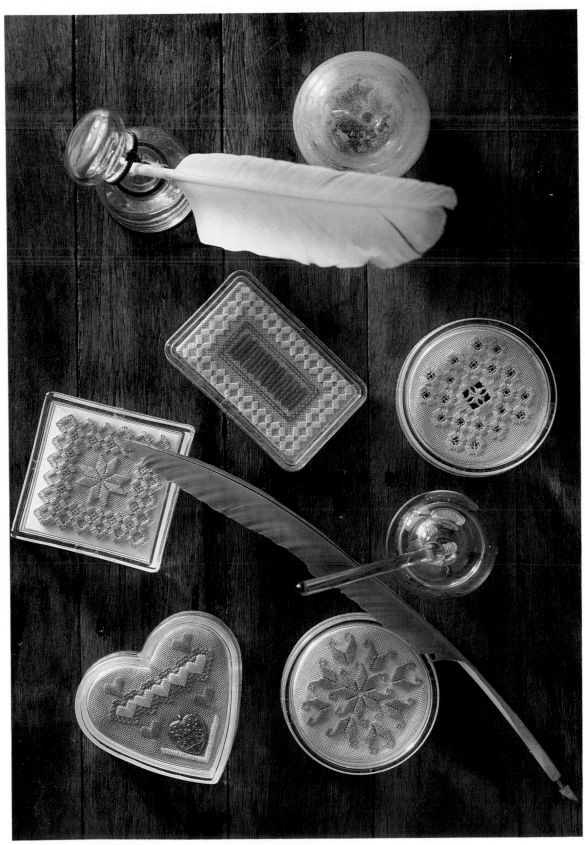

PAPERWEIGHTS

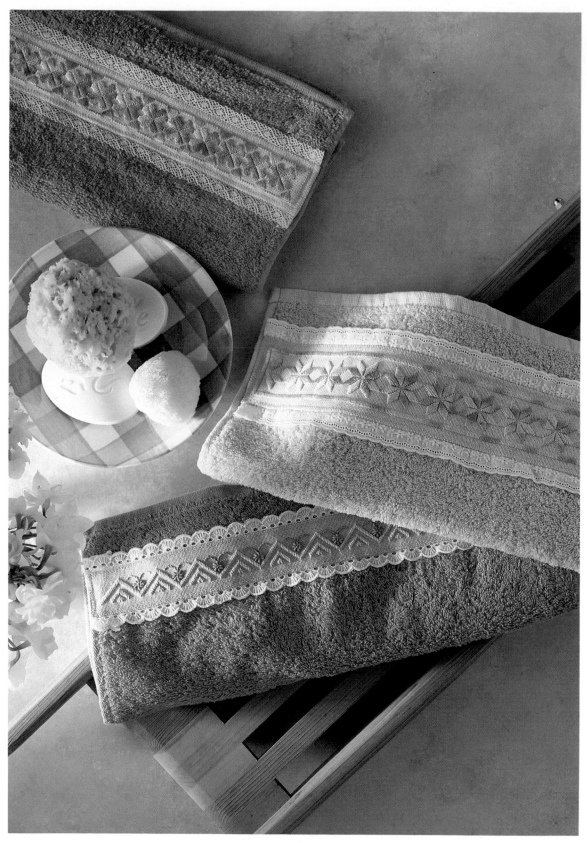

HAND TOWELS

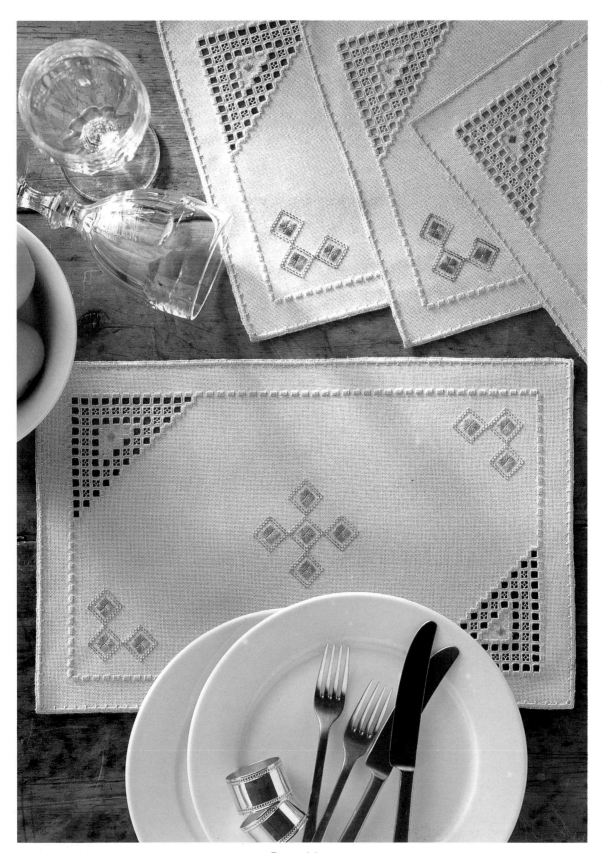

PLACE MATS

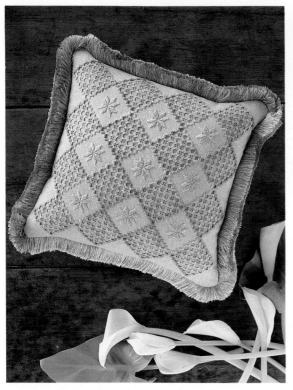

APRICOT DIAMOND AND STAR CUSHION

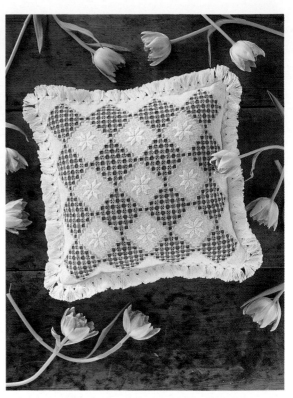

BLUE DIAMOND AND STAR CUSHION

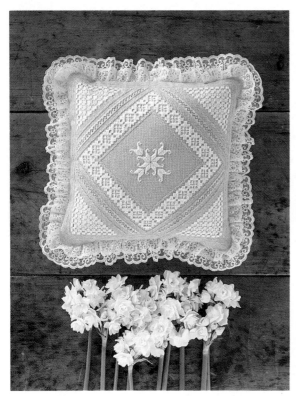

GREEN BRAID AND LACE CUSHION

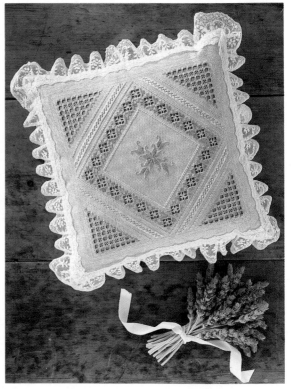

MAUVE BRAID AND LACE CUSHION

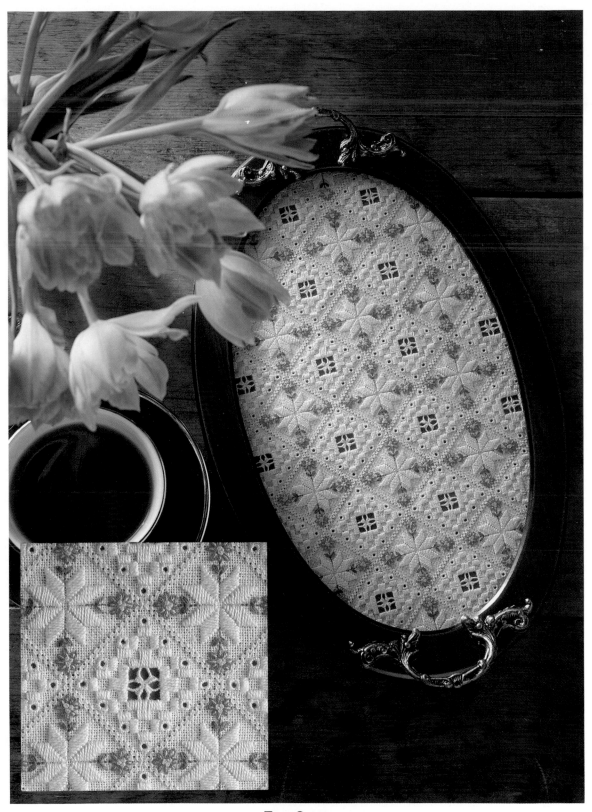

TRAY CLOTH

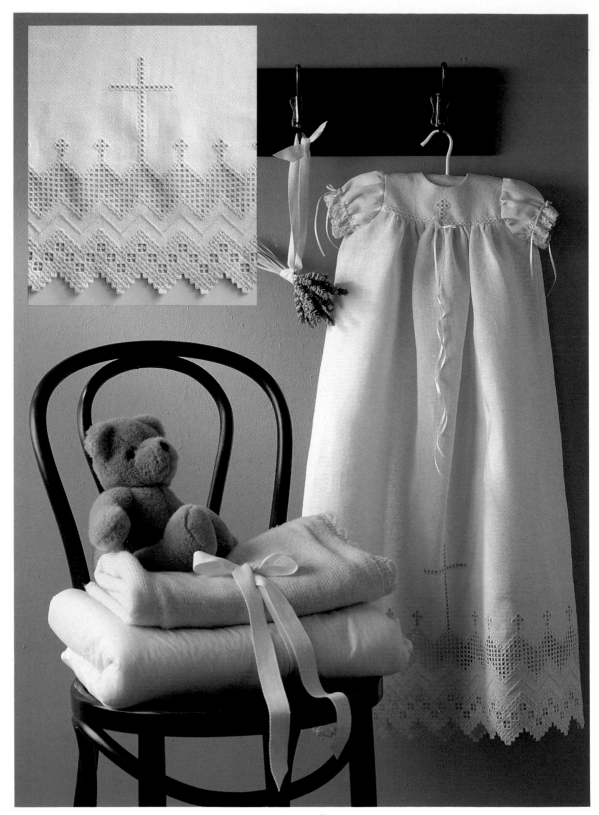

CHRISTENING GOWN

REQUIREMENTS
18 cm x 7 cm (7 in x 3 in) of blue Lugana
1 skein DMC coton perle no. 5 in colour 800
1 skein Minnamurra thread in colour 10 *or* DMC stranded thread in colour 208
Tapestry needle no. 24

METHOD
Find the centre of the fabric and use this as the starting point. Embroider the stitches in the following order:

- Satin stitch diamonds with three strands of Minnamurra thread.
- Satin stitch border in blue with coton perle no. 5.
- Buttonhole edging with coton perle no. 5.

Cut out around the outside edge from the back and then press with an iron on the wrong side. Make a tassel (see page 26) and attach it to the centre point of the bottom edge of the bookmark.

LIGHT BLUE AND WHITE BOOKMARK
Finished size: 3.5 cm x 13 cm (1⅜ in x 5 in)

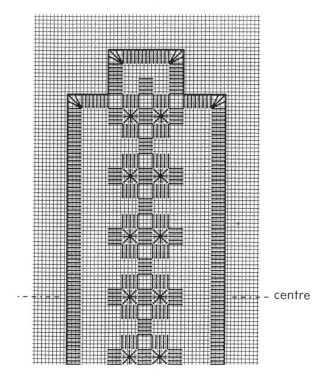

centre

Graph for light blue and white bookmark

33

REQUIREMENTS
18 cm x 7 cm (7 in x 3 in) of light blue Lugana
1 skein DMC coton perle no. 5 in white
1 ball DMC coton perle no. 8 in white
Tapestry needle no. 24

METHOD
Find the centre of the fabric and use this as the starting point. Embroider the stitches in the following order:

- Kloster blocks with coton perle no. 5.
- Eyelets with coton perle no. 8.
- Buttonhole edging with coton perle no. 5.

Cut out around the edge from the back and then press with an iron on the wrong side. Make a tassel (see page 26) and attach to the centre of the bottom edge of the bookmark.

PINK AND WHITE BOOKMARK
Finished size: 4 cm x 15 cm (1½ in x 6 in)

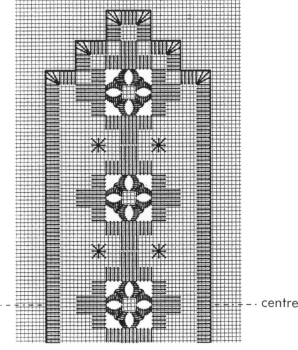

centre

Graph for pink and white bookmark

REQUIREMENTS
20 cm x 7 cm (8 in x 3 in) of white Lugana
1 skein DMC coton perle no. 5 in colour 818
1 ball DMC coton perle no. 8 in colour 818
Tapestry needles no. 24 and no. 26

METHOD
Find the centre of the fabric and use this as the starting point. Embroider the stitches in the following order:

- Satin stitch with coton perle no. 5.
- Eyelets with coton perle no. 8.
- Buttonhole edging with coton perle no. 5.
- Cut the fabric and complete the Maltese Crosses using coton perle no. 8.

Cut out around the edge from the back and then press with an iron on the wrong side. Make a tassel (see page 26) and attach it to the centre of the bottom of the bookmark.

PAPERWEIGHTS

RECTANGULAR PAPERWEIGHT
Finished size: 10.5 cm x 6 cm (4 in x 2½ in)

REQUIREMENTS
15 cm (6 in) square of blue Lugana
1 skein DMC coton perle no. 5 in white
1 skein Minnamurra thread in colour 10 *or* DMC stranded thread in colour 208
Tapestry needle no. 24
DD Creative Craft kit for rectangular paperweight
piece of medium-weight cardboard

METHOD
This piece of fabric is a square but it is embroidered into a rectangle. Start the measurements along one side. Measure 6 cm (2½ in) in from the left corner and 2 cm (¾ in) up from the bottom. This is the starting point for the embroidery. When using Minamurra thread, use three strands. Embroider the stitches in the following order:

- Kloster blocks with coton perle no. 5.
- Cable stitch with the Minnamurra thread.
- Satin stitch with the Minnamurra thread.

Press the finished embroidery on the wrong side. Trim the fabric to 3 cm (1¼ in) around the embroidery. In the kit there is a piece of self-adhesive cardboard. Using this as a template, cut another three pieces of cardboard.

Remove the paper and centre it on the back of the embroidery. Press it down firmly. Place this inside the perspex paperweight. It is a firm fit, so take the time to make sure that it fits in correctly. Trim the fabric, if neccessary, to be level with the side of the paperweight. Place the other three pieces of cardboard on top to fill in the space. Finally, remove the paper from the back of the felt and stick it carefully over the back of the paperweight. Press down firmly. The paperweight is now complete.

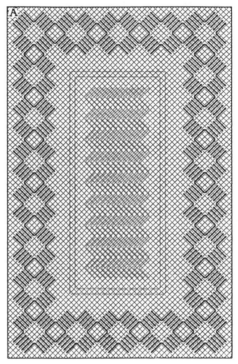

Graph for
rectangular paperweight

SQUARE PAPERWEIGHT

Finished size: 8.5 cm (3⅜ in) square

REQUIREMENTS
15 cm (6 in) square of pink Lugana
1 skein Minnamurra thread in colour 40 *or* DMC stranded thread in colour 605
1 skein Minnamurra thread in colour 150 *or* DMC stranded thread in colour 3713
Tapestry needle no. 24
DD Creative Craft kit for square paperweight
piece of medium-weight cardboard

METHOD

Measure 7 cm (2¾ in) in from the bottom left corner and up 3.5 cm (1¼ in) from the bottom. This is the starting point. Using three strands of the Minnamurra thread, embroider the stitches in the following order:

- Kloster blocks in Minnamurra thread 150.
- Star in Minnamurra thread 40.
- Eyelets in Minnamurra thread 150.
- Buttonhole stitch in Minnamurra thread 40.

Cut around the edging and press with an iron on the wrong side. Using the self-adhesive square of cardboard as a template, cut three pieces of cardboard the same size. Remove the protective paper from the back of the cardboard and centre it on the back of the embroidery. Place this inside the square of perspex. Place the three pieces of cardboard on top. Remove the paper from the back of the felt and stick it carefully onto the back of the square of perspex. Press down firmly. The paperweight is now complete.

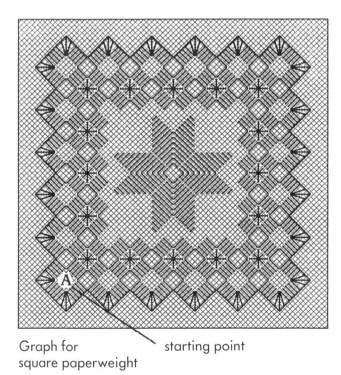

Graph for square paperweight starting point

HEART PAPERWEIGHT
Finished size: 10 cm x 9.5 cm (4 in x 3¾ in)

REQUIREMENTS
15 cm x 13 cm (6 in x 5 in) of green Lugana

1 skein DMC coton perle no. 5 white
1 skein Minnamurra thread in colour 120 *or* DMC stranded thread in colour 368
1 2.5 cm (1 in) long heart charm
1 DD Creative Craft kit for heart paperweight
piece of medium-weight cardboard

METHOD
This piece of fabric is a square, which is cut to fit the heart shape after the embroidery is completed. Measure 7 cm (2¾ in) in from the bottom left corner and 5 cm (2 in) up from the bottom edge of the fabric at this point. This is the starting point. When using the Minnamurra thread, use three strands. Embroider the stitches as follows:

- Satin stitch with the coton perle no. 5 and the Minnamurra thread.
- Cable stitch with the Minnamurra thread.

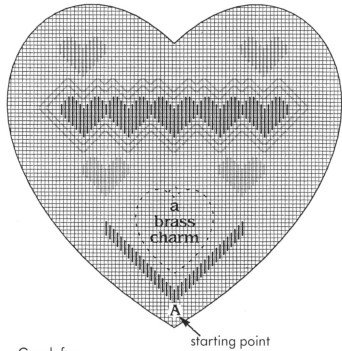

Graph for
heart paperweight

Count up 30 threads from the centre stitch of the V of satin stitching. Attach the heart charm at this point. Press with an iron on the wrong side. Using the cardboard template in the kit, cut another three heart shapes. Remove the paper from the back of the self-adhesive cardboard and centre it on the back of the

embroidery. Push it down firmly. Place this side in the perspex shape making sure that the heart charm is straight. Place the other three pieces of cardboard on top. Trim the fabric to be level with the edge of the perspex. Remove the paper from the back of the felt and stick it to the back of the perspex. Press it down firmly. The paperweight is now complete.

BLUE ROUND PAPERWEIGHT

Finished size: 9 cm (3½ in) diameter

REQUIREMENTS
15 cm (6 in) square of white Lugana
1 skein DMC coton perle no. 5 in colour 800
Tapestry needle no. 24
1 DD Creative Craft kit for round paperweight
piece of medium-weight cardboard

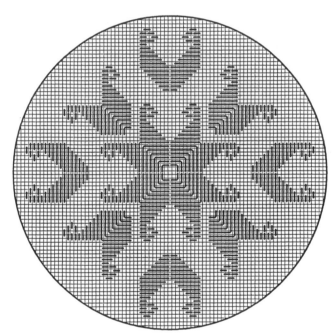

Graph for blue round paperweight

METHOD
Find the centre of the fabric. This is the starting point. The design is completely stitched in satin stitch. Complete the design and then press on the wrong side. Using the circle of self-adhesive cardboard in the kit as a template, cut another three pieces of cardboard. Remove the paper from the back of the self-adhesive cardboard and centre it on the back of embroidery. Press

down well. Place this into the perspex round and press in carefully. Place the other three pieces of cardboard on top. Trim the fabric to the edge of the perspex. Remove the paper from the back of the felt and carefully stick it over the back of the paperweight. Press down firmly. The paperweight is now complete.

PINK PAPERWEIGHT
Finished size: 9 cm (3½ in) diameter

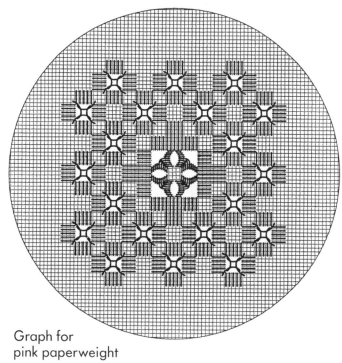

Graph for
pink paperweight

REQUIREMENTS
15 cm (6 in) square of cream Lugana
1 skein Minnamurra thread in colour 50
1 skein Minnamurra thread in colour 8050
1 skein DMC coton perle in colour no. 8
Tapestry needles no. 24 and no. 26
1 DD Creative Craft kit for round paperweight
piece of medium-weight cardboard
15 cm (6 in) square of brown fabric

METHOD
Find the centre of the fabric and use this as the starting point. When using the Minnamurra 50, use three strands. Use one strand of the Minnamurra 8050 and the coton perle no. 8. Embroider the stitches in the following order:

- Satin stitches with the Minnamurra 50.
- Klosters block with the Minnamurra 50.

Cut the fabric and work the needleweaving and square filets.

When completed press with an iron on the wrong side. Using the circle of self-adhesive cardboard from the kit as a template, cut three more pieces of cardboard. Remove the paper from the back of the self-adhesive cardboard and centre it on the back of the brown fabric. Press down firmly. Now centre the embroidery over the brown fabric. Very carefully place this inside the perspex round. Push down firmly. Place the three pieces of cardboard on top. Trim both pieces of fabric to the edge of the perspex. Remove the paper from the back of the felt and stick it over the back of the perspex. Press down firmly. The paperweight is now complete.

HAND TOWELS

BLUE HAND TOWEL

Finished size: the embroidered strip is 3.5 cm (1⅜ in) x the width of the towel

REQUIREMENTS
1 cornflower blue hand towel
8 cm (3 in) wide strip of blue Lugana as long as the width of the towel plus 5 cm (2 in)
1 skein DMC coton perle no. 5 in colour 800
1 skein Minnamurra thread in each of the following colours: 30 and 120
Tapestry needle no. 24
Crewel embroidery needle
1 piece of lace or broderie anglaise as long as twice the width of the towel plus 4 cm (1½ in)

METHOD
Find the centre of the fabric and use this as the starting point for the embroidery. When using the Minnamurra threads, use three strands. Embroider the stitches in the following order:

- Satin stitch with the coton perle no. 5.
- Bullion daisies in Minnamurra thread no. 30.

- Stems are stitched in stem stitch in Minnamurra thread no. 120. The same colour is used for a colonial knot in the centre of each daisy.

Press the finished embroidery on the wrong side. Turn under a hem of 2 cm (¾ in) on each of the long sides of the embroidered strip. Also press a 2.5 cm (1 in) hem at the end of the strip. Cut the lace in two and turn under 1 cm (½ in) on each end. The lace should now be the same length as the embroidered strip. Pin the lace to both sides of the embroidered strip, place on the towel where desired and then pin to the towel. Machine sew the embroidered strip and lace to the hand towel using either a straight or a zigzag stitch. The towel is now complete.

centre

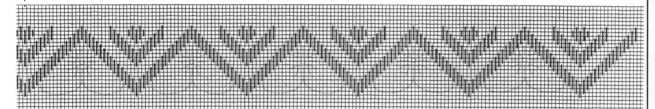

Graph for blue hand towel

GREEN HAND TOWEL

Finished size: the embroidered strip is 5.5 cm (2¼ in) x the width of the towel

REQUIREMENTS
1 sage green towel
9.5 cm (3¾ in) wide strip of beige Lugana as long as the width of the towel plus 4 cm (1½ in)
2 skeins Watercolour thread in Springtime
Tapestry needle no. 24
Piece of lace or broderie anglaise as long as twice the width of the towel plus 4 cm (1½ in)

METHOD
Find the centre of the fabric and use this as the starting point for the embroidery. The whole pattern is worked in satin stitch. When the embroidery has been finished, press with an iron on the wrong side. Turn under a 2 cm (¾ in) hem on each of the long sides of the embroidered strip and turn under 2 cm (¾ in) on each end. Cut the lace in two and turn under 1 cm (½ in) on each end. The lace should now be the same length

as the embroidered strip. Pin the lace to both sides of the embroidered strip, then pin to the towel where desired. Machine sew the embroidered strip to the towel using a straight or a zigzag stitch. The towel is now complete.

centre

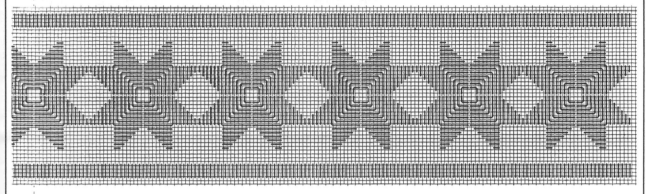

Graph for green hand towel

CORAL HAND TOWEL
Finished size: 4.5 cm (1¾ in) x the width of the towel

REQUIREMENTS
1 coral hand towel
8.5 cm (3⅜ in) strip of beige Lugana as long as the width of the towel plus 4 cm (1½ in)
Piece of lace or broderie anglaise as long as twice the width of the towel plus 4 cm (1½ in)
1 skein Watercolour thread in colour Cantaloupe
Tapestry needle no. 24

METHOD
Find the centre of the fabric strip and use this as the

centre

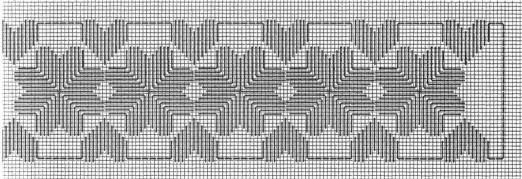

Graph for coral hand towel

starting point for the embroidery. The embroidery is stitched in the following order:

- Satin stitch.
- Back stitch.

When the embroidery is finished, press with an iron on the wrong side. Turn under a hem of 2 cm (¾ in) on each of the long sides of the embroidered strip and 2 cm (¾ in) on each end. Cut the lace in two and turn under 2 cm (¾ in) on each end. The lace should now be the same length as the embroidered strip. Pin the lace to both sides of the embroidered strip and then to the towel in the desired place. Machine sew the embroidered strip to the towel using a straight or a zigzag stitch. The towel is now complete.

PLACE MATS

Finished size: 42 cm x 27 cm (16½ in x 10½ in)
All four place mats use the same pattern. The coloured thread used to work the satin and cable stitching has been changed on each mat to add variety and colour. An alternative DMC stranded thread has been given, but you can use any colour you like. The cutwork corners are on the top left and bottom right corners of each place mat.

The graphs for the two corner and the central motifs are worked on the place mats as shown below. Use the letters as a guide to positioning.

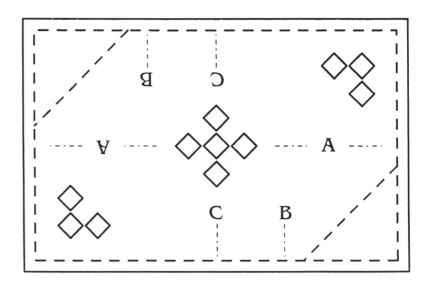

REQUIREMENTS

4 pieces of beige Lugana each 48 cm x 32 cm (18 in x 12 in)

2 balls DMC coton perle no. 5 in colour 644

1 ball DMC coton perle no. 8 in colour 644

1 skein Minnamurra thread in each of the following colours: 100, 160, 180, 200 *or* 1 skein DMC stranded thread in each of the following colours: 352, 3064, 676, 472

Tapestry needles no. 24 and no. 26

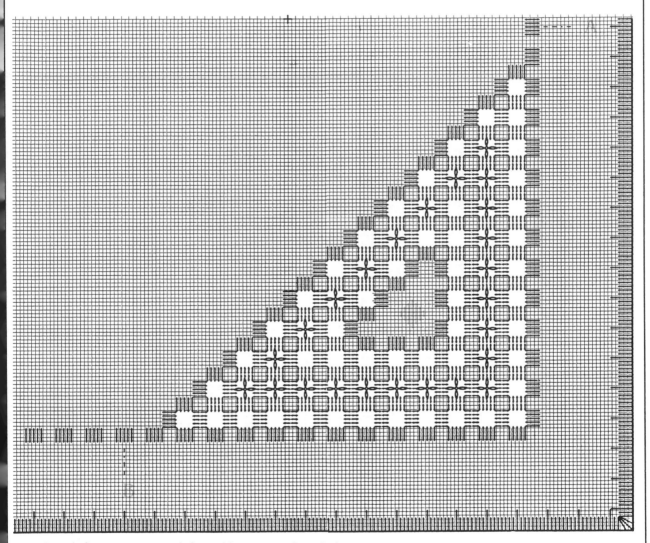

Graph for corners (top left and bottom right) of place mats

METHOD

Each piece of fabric is a rectangle. Measuring across the long side of the fabric, go in from the bottom left corner 1.5 cm (½ in) and up 1.5 cm (½ in). Use this

as the starting point for the embroidery. When using the Minnamurra or DMC stranded threads, use three strands. Embroider the stitches in the following order:

- Kloster blocks with coton perle no. 5.
- Double cable with the Minnamurra thread.
- Satin stitch the diamonds with the Minnamurra thread.
- Buttonhole stitch around the edge with the coton perle no. 5.

Cut the fabric, withdraw the threads and needleweave using the coton perle no. 8.

Cut from the back around the buttonhole stitching. Press with an iron on the wrong side. Repeat this process with the remaining three place mats, changing the colour of the Minnamurra or DMC stranded thread for each mat.

Graph for corners (top right and bottom left) of place mats

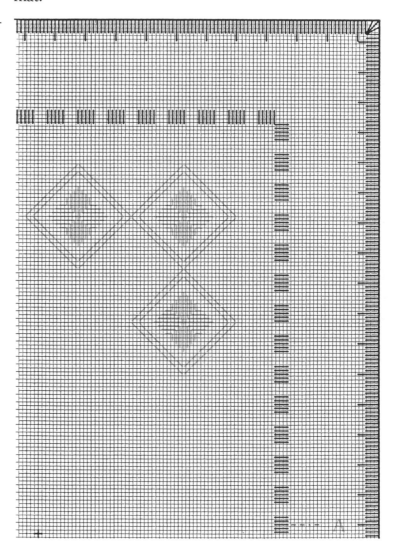

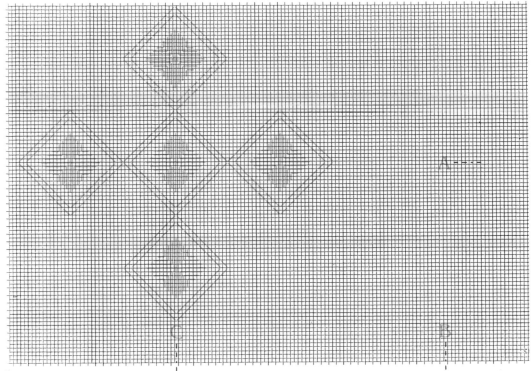

Graph for centre of place mats

BLUE DOILY

Finished size: 44 cm x 25.5 cm (17¼ in x 10 in)

REQUIREMENTS
50 cm x 30 cm (22 in x 12 in) of blue Lugana
2 balls DMC coton perle no. 5 in white
1 ball DMC coton perle no. 8 in white
1 skein Minnamurra thread in each of the following
colours: 20, 30, 80 and 100 *or* 1 skein DMC stranded
thread in each of the following colours: 369, 352, 211
and 603
2 skeins Minnamurra thread in colour 10 *or* 2 skeins
DMC stranded thread in colour 208
Tapestry needles no. 24 and no. 26

METHOD
Find the centre of the fabric and use this as the starting
point. When using Minnamurra threads or DMC
threads, use three strands. Embroider the stitches in the
following order:

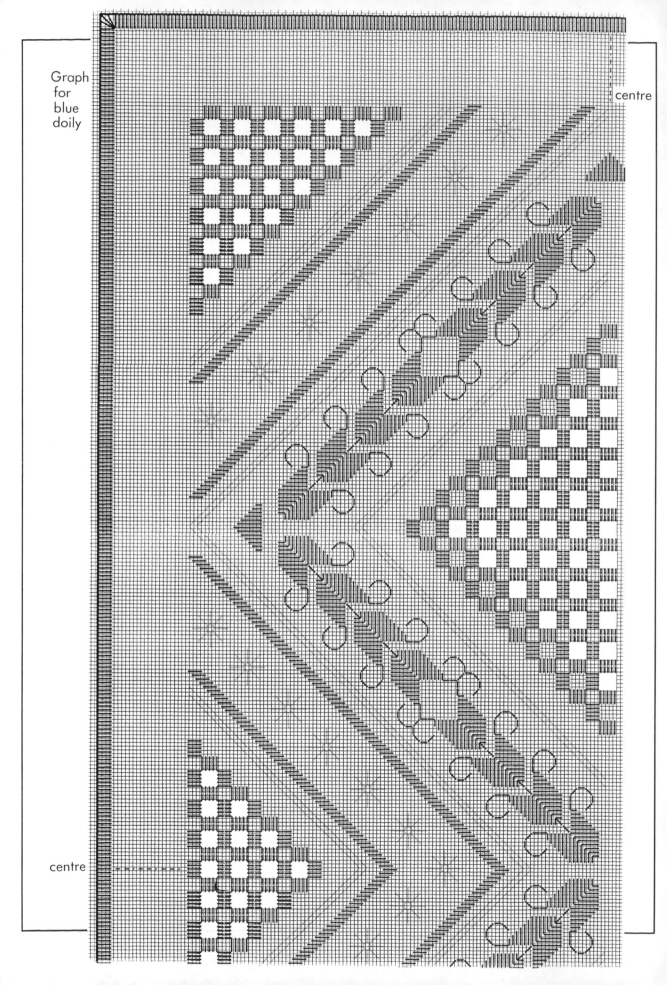

Graph
for
blue
doily

centre

centre

- Satin stitch diamonds with curly ends with white coton perle no. 5.
- Cable stitch in Minnamurra thread.
- Kloster blocks in the centre of each large diamond with white coton perle no. 5.
- Satin stitch lines on the outside of the design with white coton perle no. 5.
- Cable stitch in Minnamurra thread next to the satin-stitch lines.
- Kloster blocks for each corner with white coton perle no. 5.
- Cut the fabric, withdraw the threads and needleweave in the centre of each large diamond with coton perle no. 8.
- Buttonhole stitch around the outside edge with coton perle no. 5.
- For the daisies, work a cross of bullion stitches (indicated by a star on the graph). Then work two more bullion stitches between each of the original bullion stitches.

When the buttonhole stitching is completed, cut out around the edge from the back. Press with an iron on the wrong side.

CUSHIONS

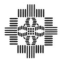

I have designed two cushions for this book. Each design has been embroidered twice, using different colours. This is to demonstrate the difference that colour can make. With the Diamond and Star cushion, I have used two Watercolour threads, one of which is mostly in apricot shades and the second in shades of blue. With the Braid and Lace cushions, I have used a green and a mauve Lugana fabric. The mauve cushion was done with a finer thread than the green cushion and has a more delicate finish. A piece of fabric is placed between the embroidery and the cushion insert to enhance the embroidery. I have given the colour that I used in the instructions, but you may choose another colour if you wish.

APRICOT DIAMOND AND STAR CUSHION
Finished size: 32 cm (12½ in) square

REQUIREMENTS
38 cm (15 in) square of beige Lugana
1 skein Watercolour thread in colour Apricot Blush
2 skeins Wildflower thread in colour Apricot Blush
1 skein DMC coton perle no. 5 in colour 644
Tapestry needles no. 24 and no. 26
38 cm (15 in) square of apricot fabric
34 cm x 37 cm (13¼ in x 14½ in) of beige Lugana for
the back of the cushion
30 cm (12 in) beige zipper

centre

centre

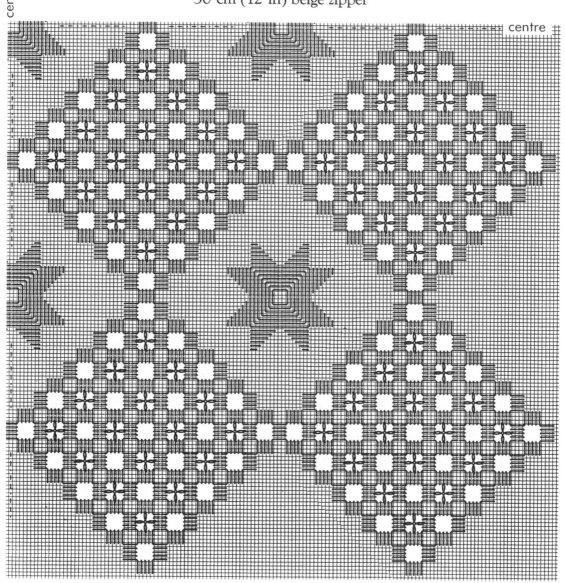

Graph for star and diamond cushions

1.5 m (1½ yd) fringing to match the cushion
35 cm (14 in) cushion insert

METHOD
Find the centre of the fabric and use this as the starting point. Embroider the stitches in the following order:

- Kloster blocks with the Watercolour thread.
- Stars with the coton perle 644.
- Cut the fabric, withdraw the threads and needleweave with the Wildflower thread.

When the embroidery is finished, press with an iron on the wrong side. Using the instructions on page 54, complete the cushion.

BLUE DIAMOND AND STAR CUSHION
Finished size: 32 cm (12½ in) square

REQUIREMENTS
38 cm (15 in) square of white Lugana
1 skein Watercolour thread in colour Sky Blue Pink
2 skeins Wildflower thread in colour Sky Blue Pink
1 skein coton perle no. 5 in white
Tapestry needles no. 24 and no. 26
38 cm (15 in) square of mid blue fabric
34 cm x 37 cm (3⅓ in) x 14½ in) of white Lugana for the back of the cushion
30 cm (12 in) white zipper
1.5 m (1½ yd) fringing
35 cm (14 in) cushion insert

METHOD
Find the centre of the fabric and use this as the starting point. Embroider the stitches in the following order:

- Kloster blocks in the Watercolour thread.
- Stars with the coton perle.
- Cut the fabric, withdraw the threads and needleweave with the Wildflower thread.

When the embroidery is finished, press with an iron on the wrong side. Using the instructions on page 54, complete the cushion.

GREEN BRAID AND LACE CUSHION
Finished size: 28 cm (11 in) square

REQUIREMENTS
30 cm (12 in) square of green Lugana
1 ball DMC coton perle no. 5 in colour 712
1 ball DMC coton perle no. 8 in colour 712

1 skein Minnamurra thread in colour 190 *or* DMC stranded thread in colour 407
Tapestry needles no. 24 and no. 26
30 cm (12 in) square of cream fabric
30 cm x 32 cm (12 in x 12½ in) of green Lugana for the back of the cushion
25 cm (10 in) green zipper
1.5 m (1½ yd) gathered lace
30 cm (12 in) cushion insert

METHOD
Find the centre of the fabric and use this as the starting point. When using the Minnamurra thread, use three strands. Embroider the stitches in the following order:

- Satin stitch the ship motif in the centre with the coton perle no. 5. With the star and ship motifs, always start at the centre of each block and work towards

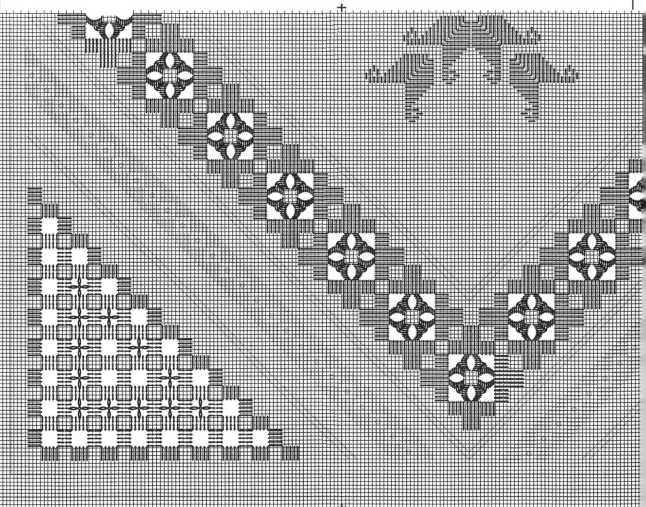

Graph for braid and lace cushions

the outside. Run the thread under the block on the wrong side to the starting point for the next block.

- Cable stitch in the Minnamurra thread.
- Satin stitch squares in coton perle no. 5.
- 1 row of cable stitch in the Minnamurra thread.
- Satin stitch embroidered edging with colonial knots in the centre of the Minnamurra thread.
- Another row of cable stitch in the Minnamurra thread.
- Kloster blocks in coton perle no. 5.
- Cut the fabric, withdraw the threads and needleweave in coton perle no. 8.
- Two rows of back stitching around the outside in Minnamurra thread.

When the embroidery is completed, press with an iron on the wrong side. Following the instructions on page 54, make up the cushion.

MAUVE BRAID AND LACE CUSHION
Finished size: 34 cm (13¼ in) square

REQUIREMENTS
38 cm (14 in) square of mauve Lugana
1 ball DMC coton perle no. 8 in colour 3042
1 ball DMC coton perle no. 12 in colour 3042
1 skein Minnamurra thread in colour 20
Tapestry needle no. 26
36 cm (14 in) square of dark mauve fabric
36 cm x 38 cm (14 in x 15 in) of mauve Lugana for the back of the cushion
25 cm (10 in) mauve zipper
1.5 m (1½ yd) gathered lace
35 cm (14 in) cushion insert

METHOD
Find the centre of the fabric. Use this as the starting point. When using the Minnamurra thread, use three strands. Embroider the stitches in the following order:

- Satin stitch the ship motif in the centre with the coton perle no. 8. With the star and ship motifs, always start at the centre of each block and work towards the outside. Run the thread under the block on the wrong side to the starting point for the next block.
- Cable stitch with the Minnamurra thread.
- Satin stitch squares in coton perle no. 8.
- Row of cable stitch in the Minnamurra thread.

- Satin stitch edging with colonial knots in the centre in the Minnamurra thread.
- Another row of cable stitch in the Minnamurra thread.
- Kloster blocks in coton perle no. 8.
- Cut the fabric, withdraw the threads and needleweave in the coton perle no. 12.
- Two rows of back stitching around the outside in Minnamurra thread.

When the embroidery is completed, press with an iron on the wrong side. Following the instructions on page 54, make up the cushion.

MAKING UP THE CUSHIONS

Take the fabric that is to go behind the embroidery and with the right side of this fabric to the wrong side of the embroidery, pin and sew the two pieces together.

With the piece of Lugana for the back of the cushions, cut the fabric in half. For example, with the apricot cushion, the backing fabric is 34 cm x 37 cm (13¼ in x 14½ in). This is cut to make two pieces each 17 cm x 37 cm (6⅝ in x 14½ in). Press a hem 2 cm (¾ in) along the newly cut edge. Machine sew these two pieces together along the pressed hem line for 5 cm (2 in) from each end. Pin the zipper to the fabric along the unsewn seam between the sewn edges. Sew the zipper in.

If using fringing or lace, measure the distance around the outside of the cushion, 1.5 cm (½ in) in from the edge. Add 3 cm (1¼ in) to that measurement if using lace. Cut the lace to that measurement and then sew the lace together with a 1.5 cm seam to make a circle. With right sides together, pin the fringing or lace, with the uncut edge of the fringing or the gathered edging of the lace to the outside, to the back of the cushion. Sew the fringing or lace to the fabric.

Undo the zipper on the back piece of the cushion. With right sides together, pin the front of the cushion to the back. Pin over the edge of the fringing or lace. Sew the front to the back. Turn the cushion to the right side through the open zipper and check that all the fringing or lace is sewn in and the line of stitching is not showing. Turn inside out again. Trim across the corners and overlock or zigzag stitch the edging of the cushion. Turn to the right side again and push out the corners so they are neat. Push in the cushion insert and do up the zipper. The cushion is now finished.

TRAY CLOTH

Finished size: 29 cm x 16 cm (11 in x 6¼ in)

REQUIREMENTS
35 cm x 22 cm (13¾ in x 8¾ in) of cream Belfast linen
1 ball DMC coton perle no. 8 in colour ecru
1 ball DMC coton perle no. 12 in colour ecru
1 skein Flower thread in each of the following colours:
2572, 2574, 2738, 2501
Tapestry needle no. 26
tray kit
35 cm x 22 cm (13¾ in x 8¾ in) smoky green fabric
for the backing

METHOD
Use one of the oval pieces of cardboard in the kit as
a template and trace around the edge with a pencil on
the linen. Make sure that the template is straight on
the fabric. Find the centre of the fabric and use this
as the starting point. Embroider the stitches in the
following order:

- Cable stitch diamonds with the coton perle no. 12.
- Satin stitch stars with the coton perle no. 8.
- Satin stitch squares with the coton perle no. 8.
- Eyelets with the coton perle no. 12.
- Lazy daisy stitch flowers in Flower thread 2572, with
 a straight stitch in each petal of Flower thread 2574.
- Stems and leaves in Flower thread 2501, with a
 straight stitch in each leaf in the same colour.
- Three colonial knots in Flower thread 2738 for the
 centres of the flowers.
- Cut the fabric, withdraw the threads and work the
 Maltese Crosses in coton perle no. 12.

When the work is complete, press with an iron on the
wrong side. I used a smoky green taffeta as the backing
fabric for the tray cloth, however, you may use a
different colour if you prefer it. Whatever colour is
chosen, it should highlight one of the colours in the
embroidery. A cream background will not be as effective
in highlighting the embroidery as a dark colour.

There is a piece of cardboard that is self-adhesive on
one side in the kit. Remove the paper from the adhesive

side and carefully place the green fabric over it. Press it down firmly, making sure there are no wrinkles in the fabric. Carefully centre the embroidery over this and place inside the tray. It may take several tries to centre the embroidery properly. Trim both the fabrics

This design is repeated over the whole area of the tray cloth as shown below

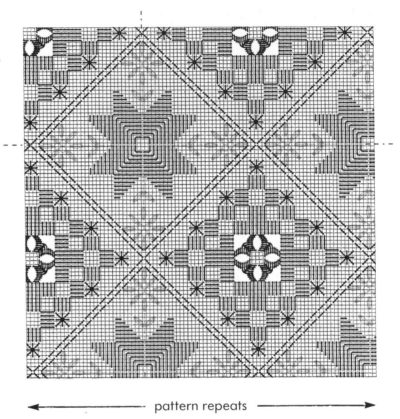

pattern repeats

centre

centre

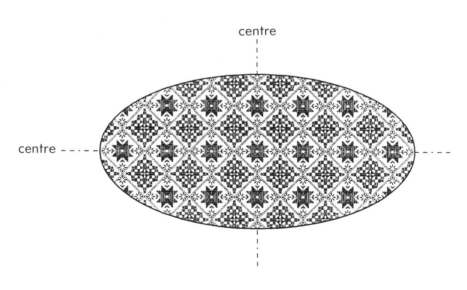

Graph for tray cloth

to the height of the tray edge. Place the other pieces of cardboard on top to fill in the space. Carefully remove the paper from the back of the self-adhesive felt and place on top of the cardboard, sticking it to the edging of the tray. Attach the legs, if desired.

CHRISTENING GOWN

The christening gown has been made from a pattern for a six-month-old child. The pattern needs to have a yoke with a gathered skirt. The skirt is easier to make if the pattern is completely split down the back because the Belfast linen tends to fray badly if it is split only partway.

REQUIREMENTS
1 m cream Belfast linen, if the front and back skirt are no longer than 86 cm (34 in)
3 balls DMC coton perle no. 8 in ecru
1 ball coton perle no. 12 in ecru
1 reel DMC Fil *or* clair light gold thread
Tapestry needle no. 26
1 m x 5 mm wide cream entredeux
2 m x 2 mm (⅛ in) wide cream ribbon

METHOD
Starting on the front skirt first, find the centre of the bottom edge of the fabric. Count up 50 threads from the bottom edge and use this as the starting point. Embroider the stitches in the following order for the first border:

- Kloster blocks with coton perle no. 8.
- Squares with coton perle no. 8.
- Eyelets with coton perle no. 12.
- Cut the fabric, withdraw the threads and complete the squares by working the Maltese Crosses with coton perle no. 12.

Count up 20 rows from the kloster blocks and work the double cable stitch. Count up a further 20 rows from the double cable stitch and work the second border in the following order:

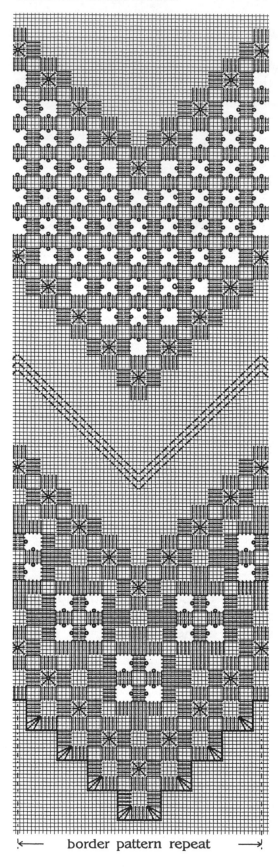

Graph for
christening
gown border

← border pattern repeat →

- Kloster blocks with coton perle no. 8.
- Eyelets with coton perle no. 12.
- Cut the fabric, withdraw the threads and needleweave with coton perle no. 12. Make sure you have a vertical row of satin stitch at the end of the border, so that the threads will not pull out.
- Buttonhole stitch the edging with coton perle no. 8.

Find the centre of the embroidery (an inverted V of kloster blocks as shown on the graph), then embroider as follows:

- Large cross in coton perle no. 8 above the inverted V.
- Small crosses above each of the other points with coton perle no. 8.
- Eyelets with the gold thread.

For the back skirt, work the border in the same order as for the front but omit the crosses.

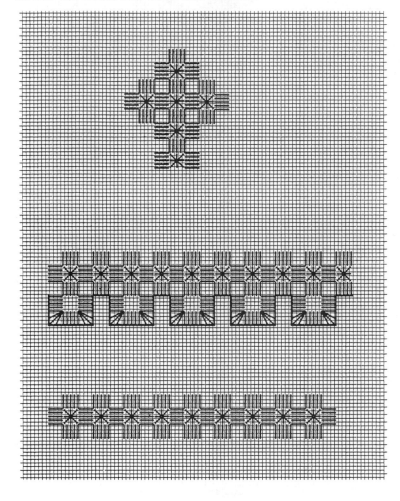

Graph for small cross on christening gown

Graph for christening gown sleeve pattern

Graph for christening gown yoke pattern

For the yoke, find the centre, taking into account the seam allowance, and embroider as follows:

- Row of kloster blocks with coton perle no. 8, as shown on the graph.
- Embroider a small cross above the centre kloster block.
- Eyelets in gold thread.

Graph for large cross on christening gown

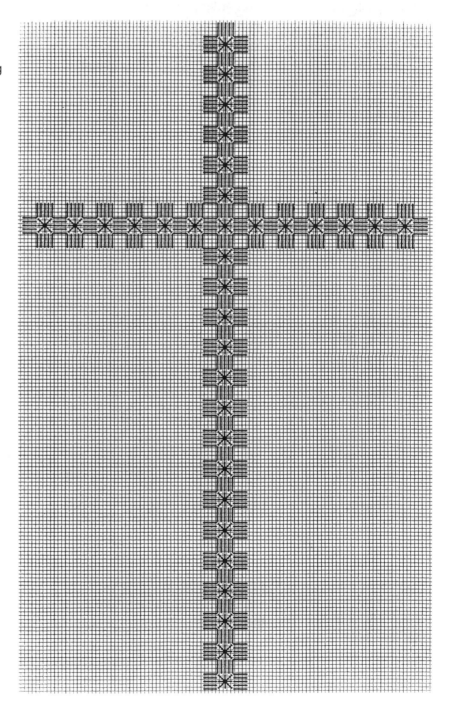

For the sleeves, find the centre and count up eight threads from the edge of the fabric. Use this as the starting point. Embroider the stitches in the following order:

- Kloster blocks with coton perle no. 8.
- Eyelets with coton perle no. 12.
- Buttonhole stitching with coton perle no. 8.

Make up the gown following the pattern instructions. Be careful to overlock all the edges to prevent fraying. Elastic can be used to gather the sleeves, but I used entredeux and ribbon as I felt this was more in keeping with the embroidered gown. Sew the entredeux on after the sleeve has been sewn up and then thread the ribbon through. Pull up the ribbon and tie into a bow.

With the remaining piece of 5 mm-wide ribbon, tie a small bow with long ends and attach to the centre front of the christening gown, below the row of kloster blocks.

LIST OF SUPPLIERS

Minnamurra Threads
PO Box 374
Glebe, NSW 2037
Tel: (02) 552 3135

Ireland Needlecraft
4/24 Keppel Dr
Hallam, Victoria 3803
Tel: (03) 702 3222 Fax: (03) 702 3255

Down Under Designs (Elizabeth White)
Suite 3
559 Sydney Rd
Seaforth, NSW 2092
Tel: (02) 948 5575 Fax: (02) 949 1735

DMC Threads (Effie Mitrofanis)
51-55 Carrington Rd
Marrickville, NSW 2204
Tel: (02) 559 3088 Fax: (02) 559 5338

DD Creative Crafts
PO Box 565
Ringwood, Victoria 3134
Tel: (03) 874 8900 Fax: (03) 874 8035